Frank draws from his soul and jeez, I'm not even sure from where else. No really. I've seen him draw. His work is kinetic, emotional, and like no one else. Coloring his drawings will bring you into his world, even as you add part of yourself to it. Color like the wind!

Bryan (Breadwig) Ballinger www.breadwig.com

This book is dedicated to Reuben & Emily.

Special thanks to Kara, Brian, and Steve.

© Frank Louis Allen 2016

All the images of this book are the sole properety of Frank Louis Allen. They are not to be reproduced, copied, or used for any purpose except Coloring.

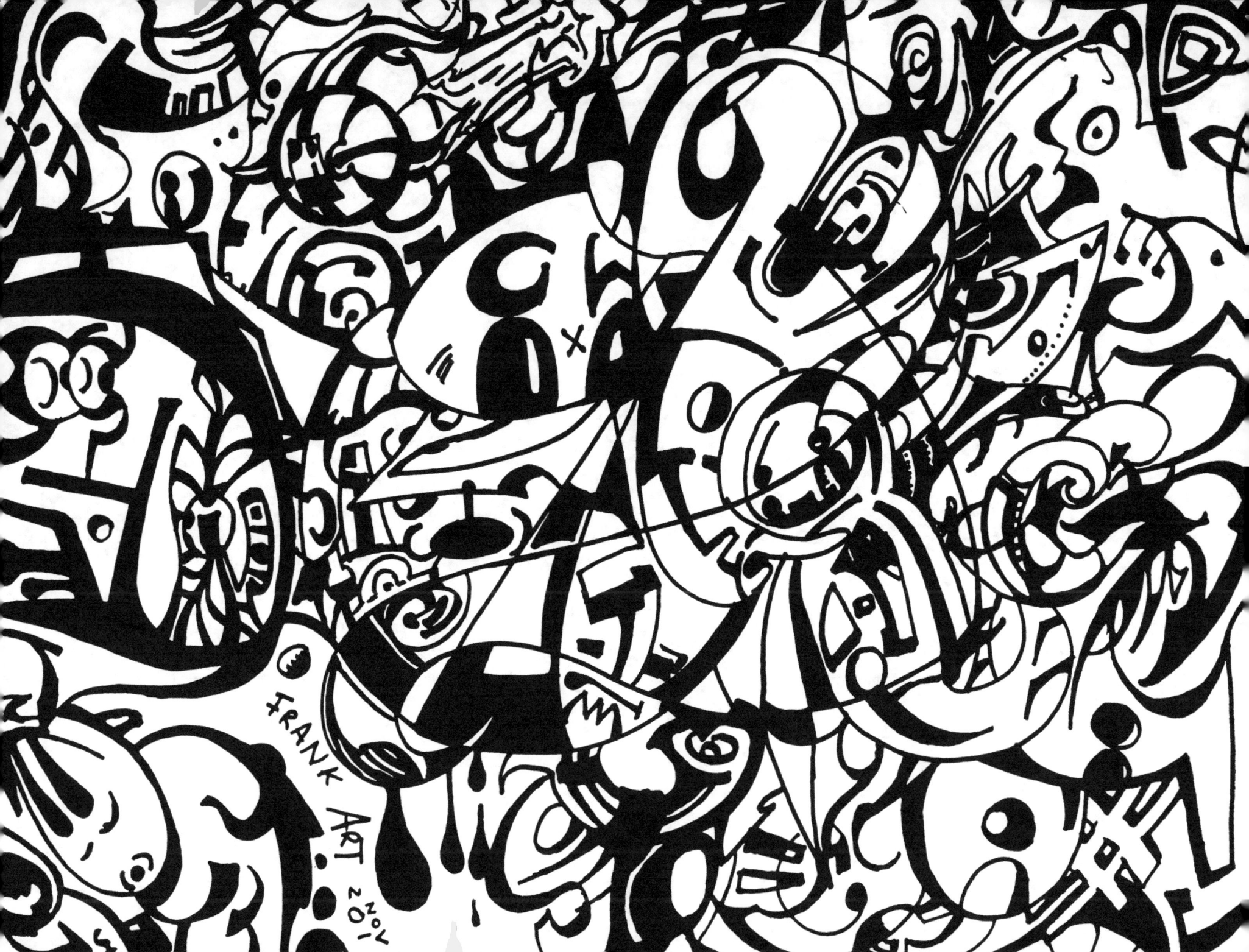

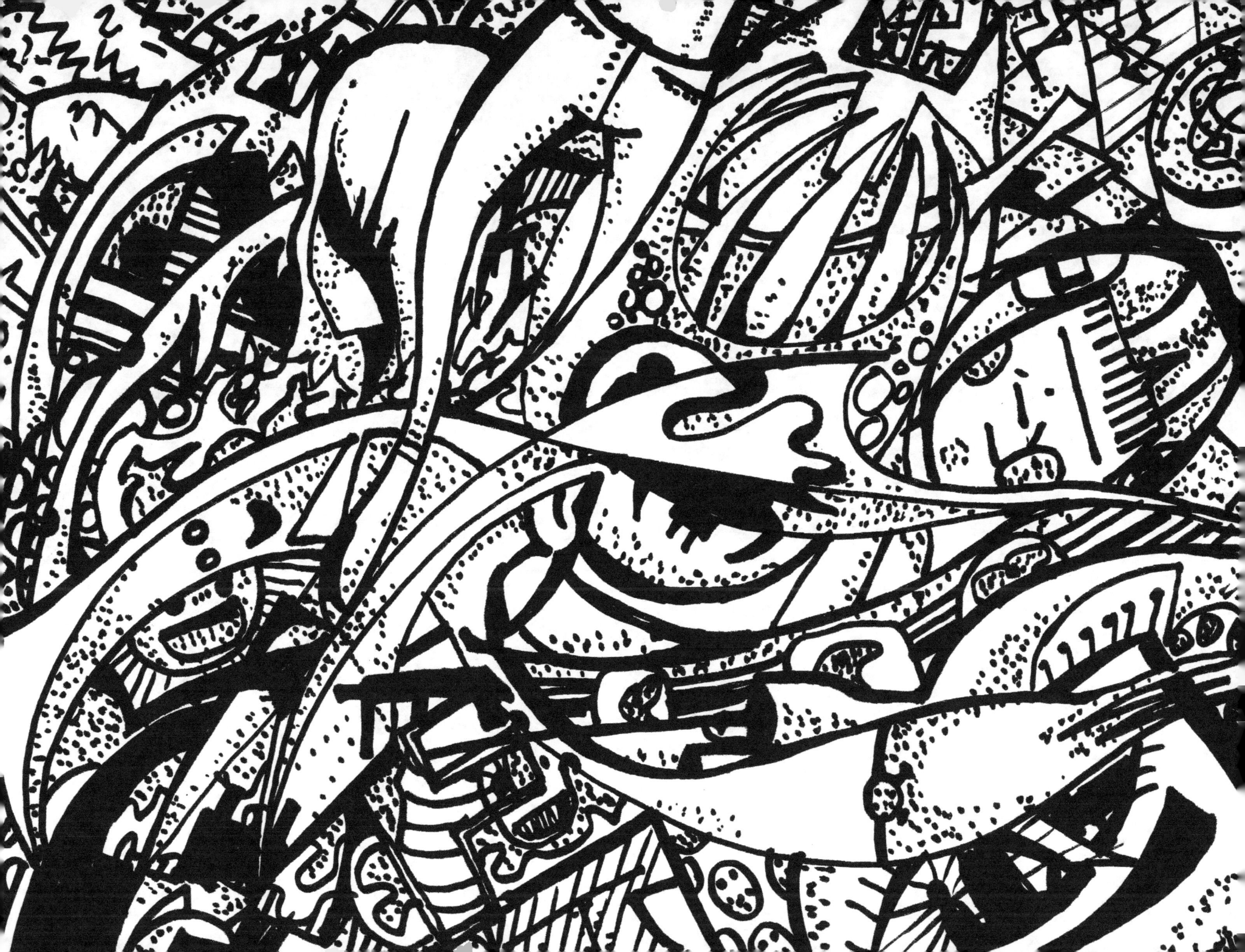

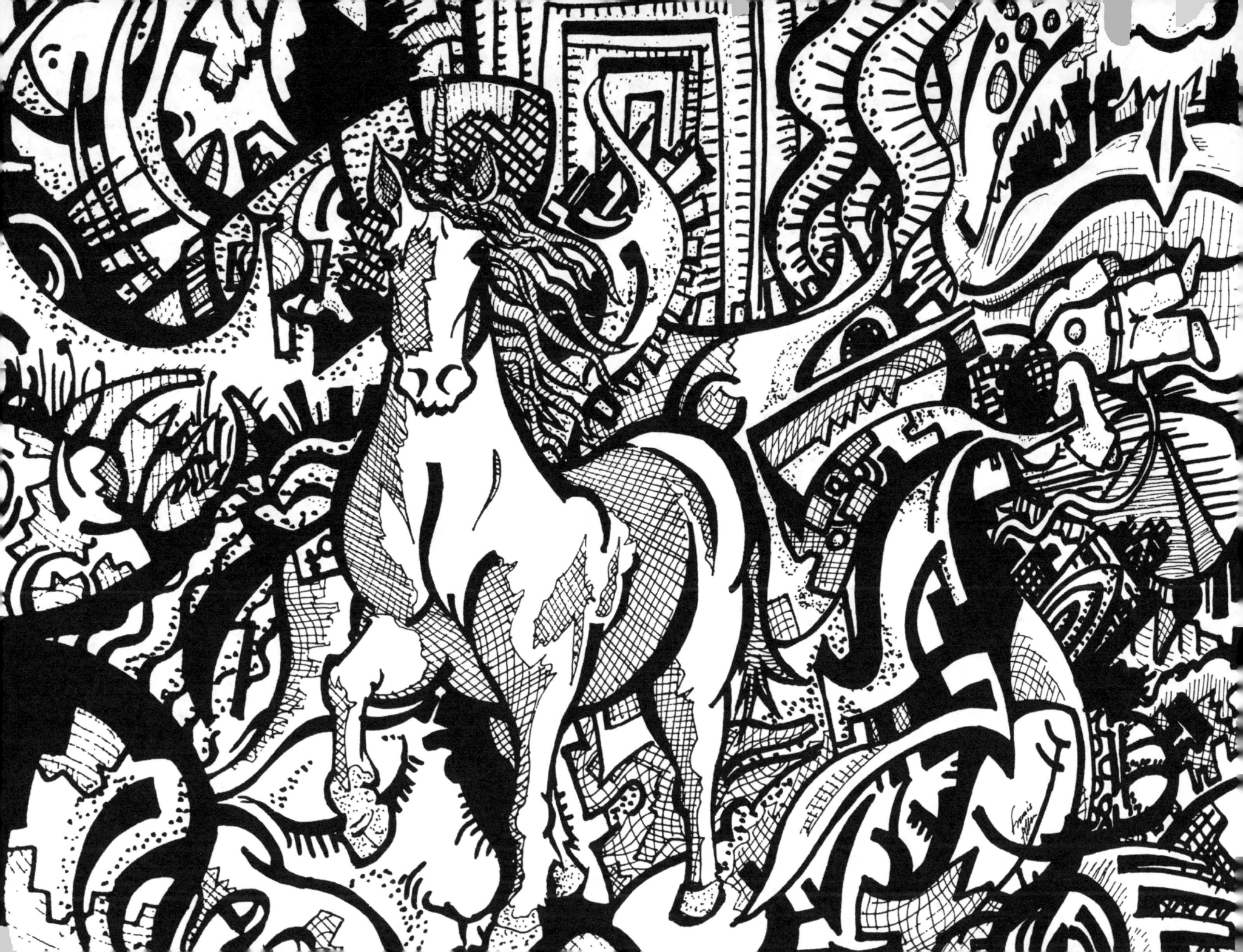

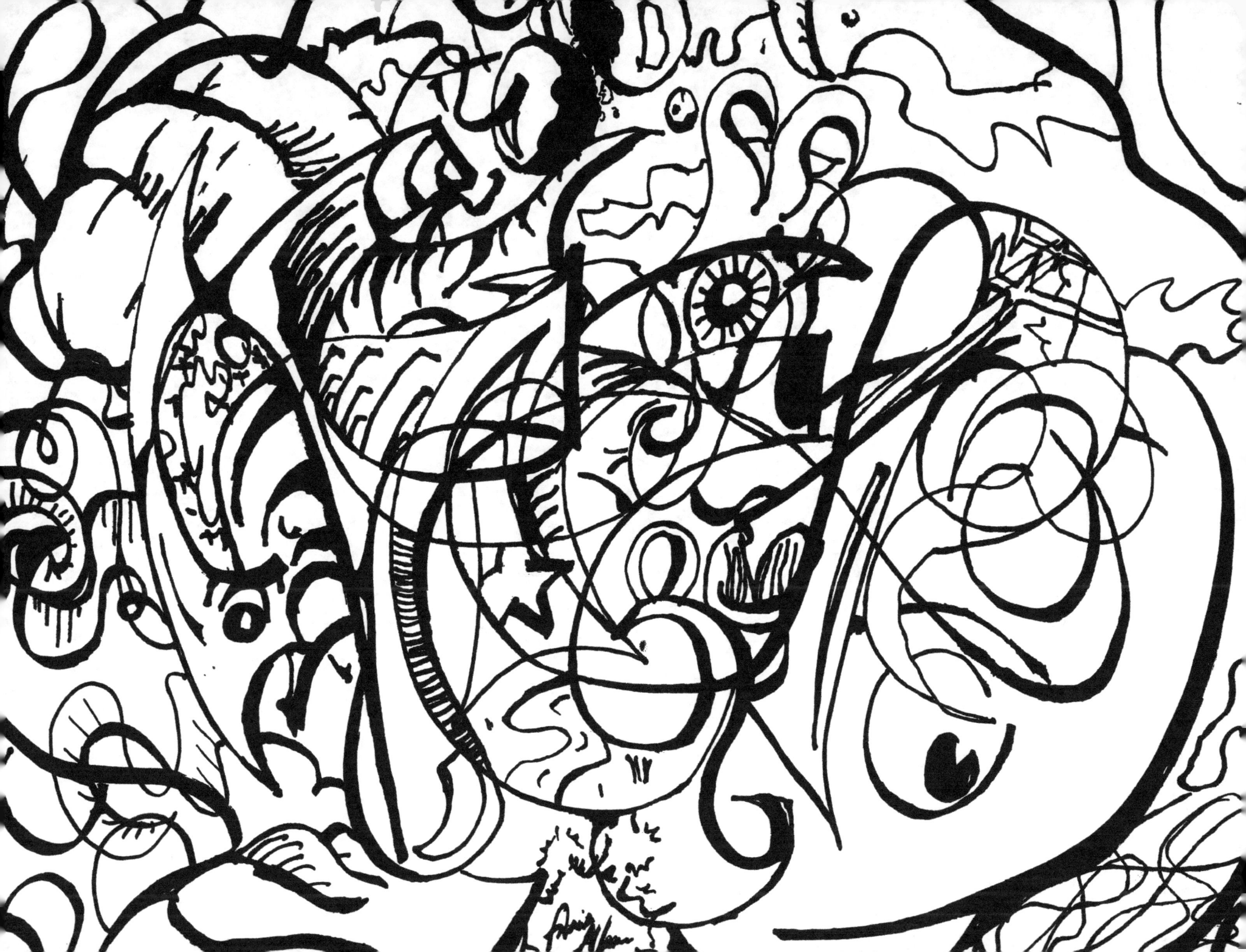

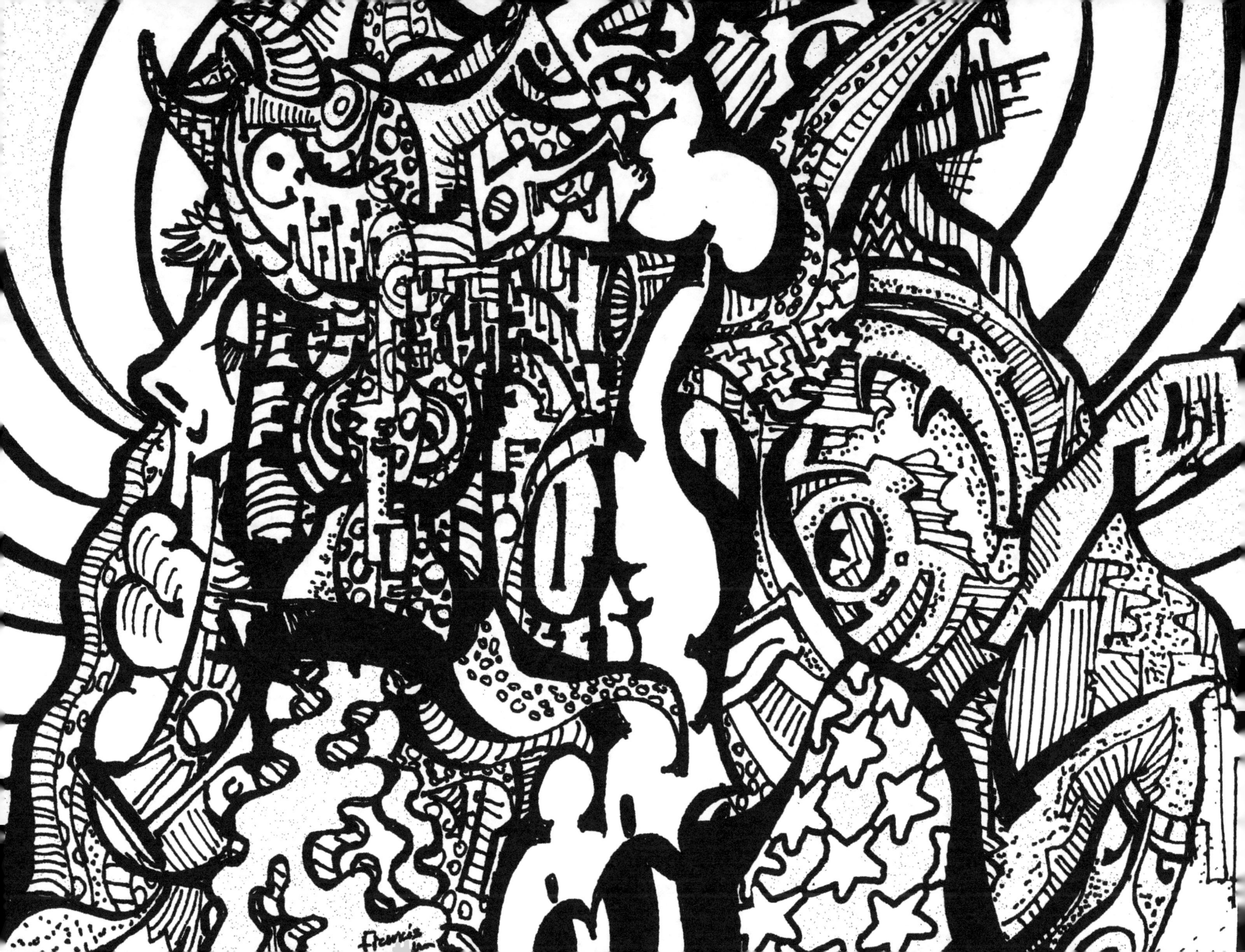

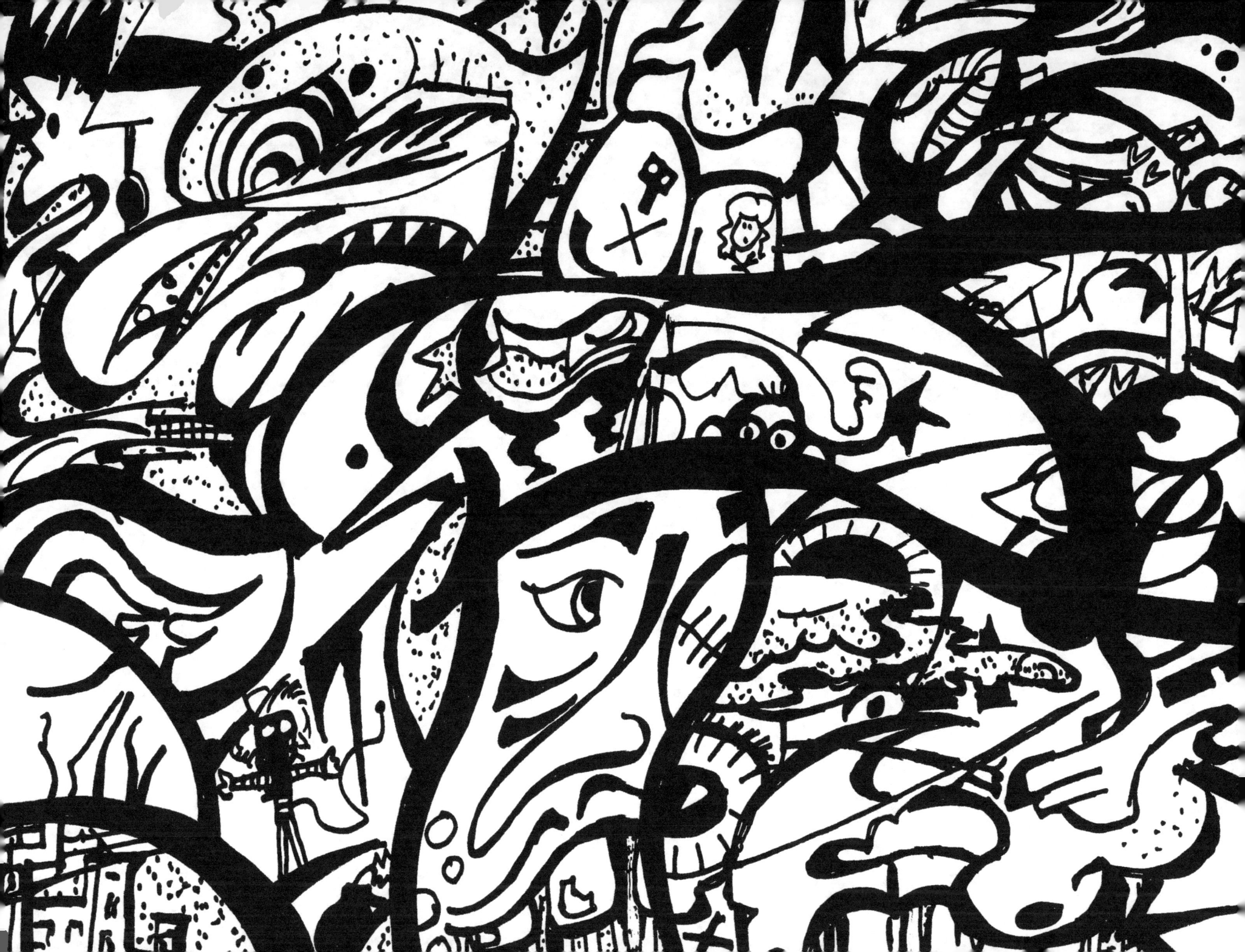

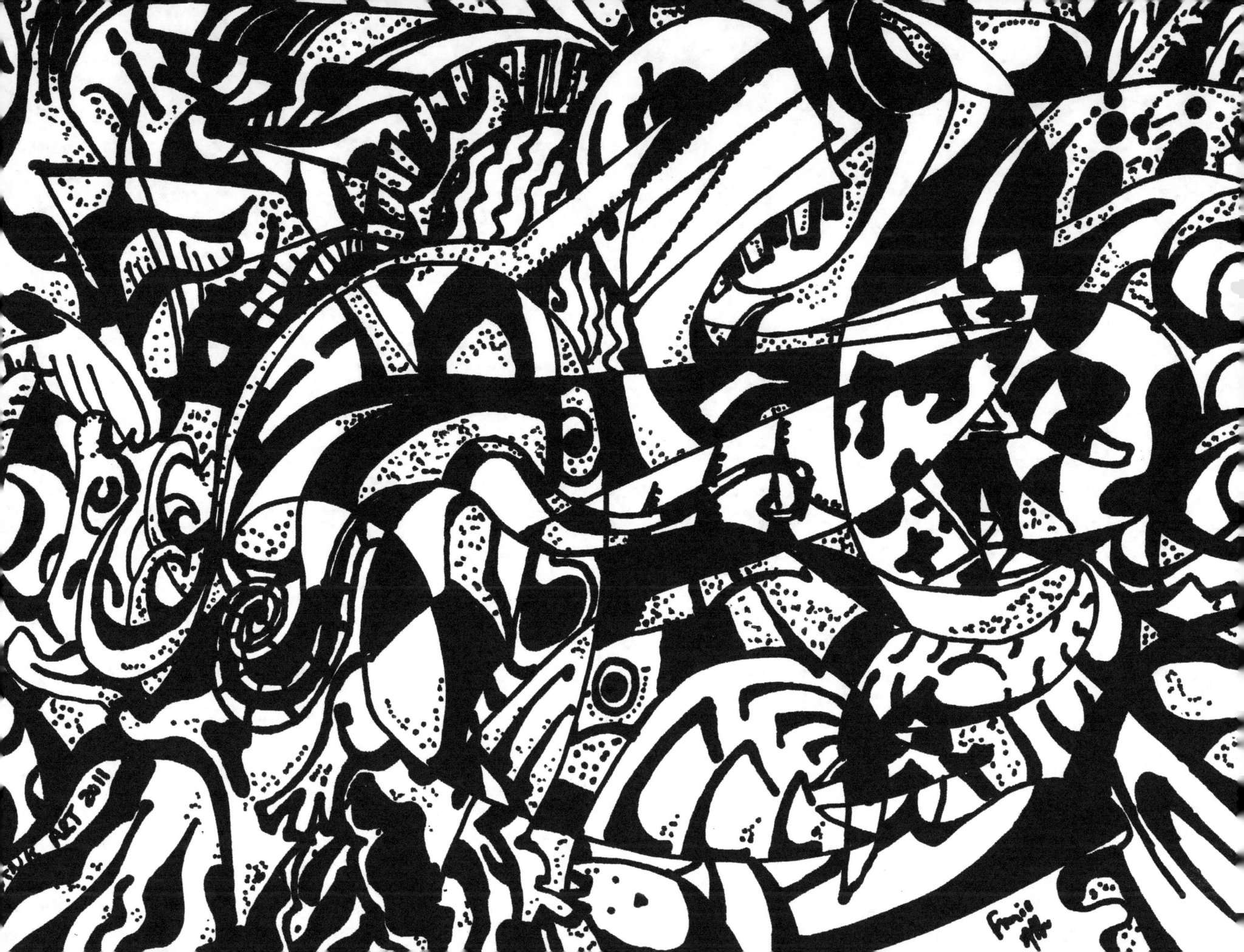

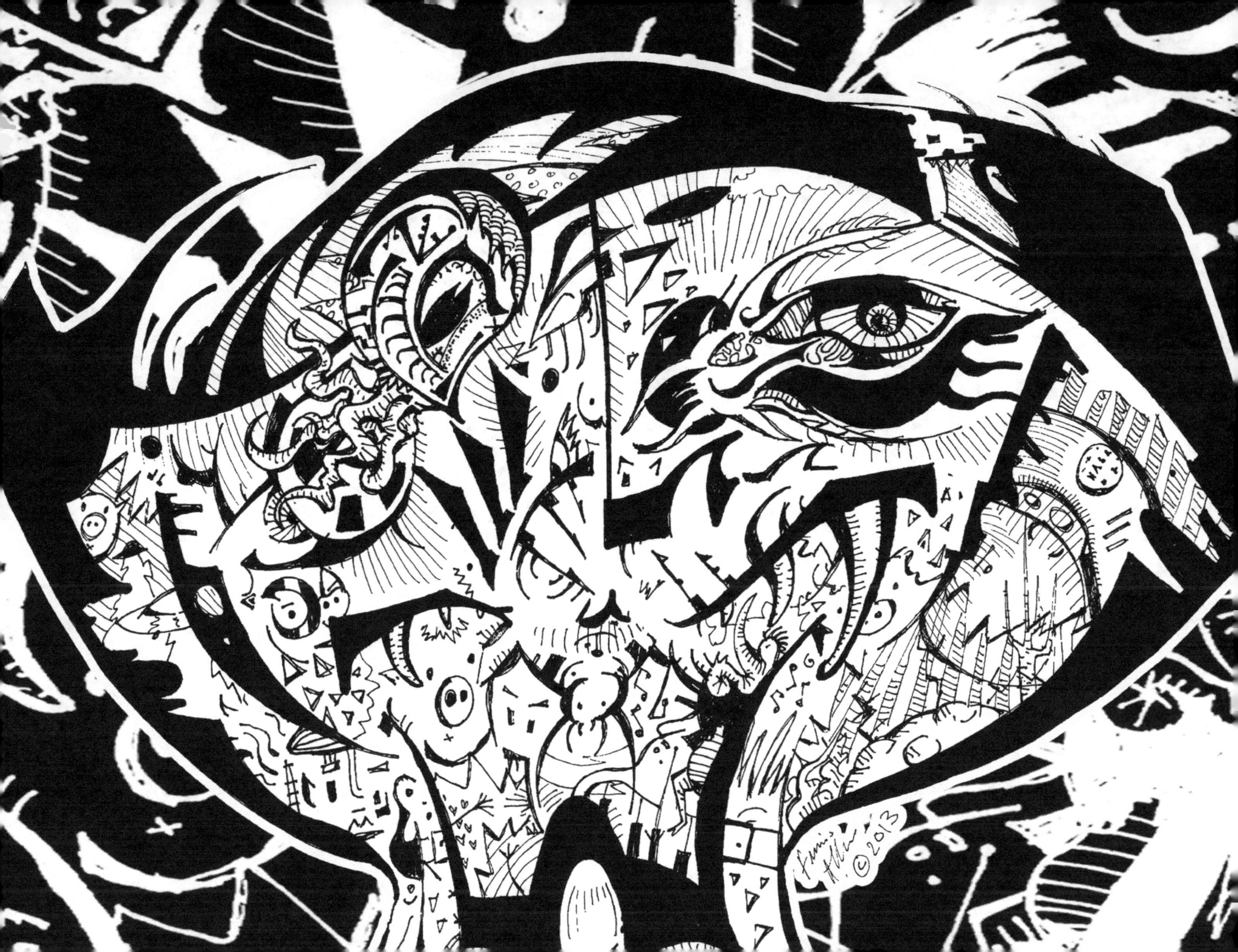

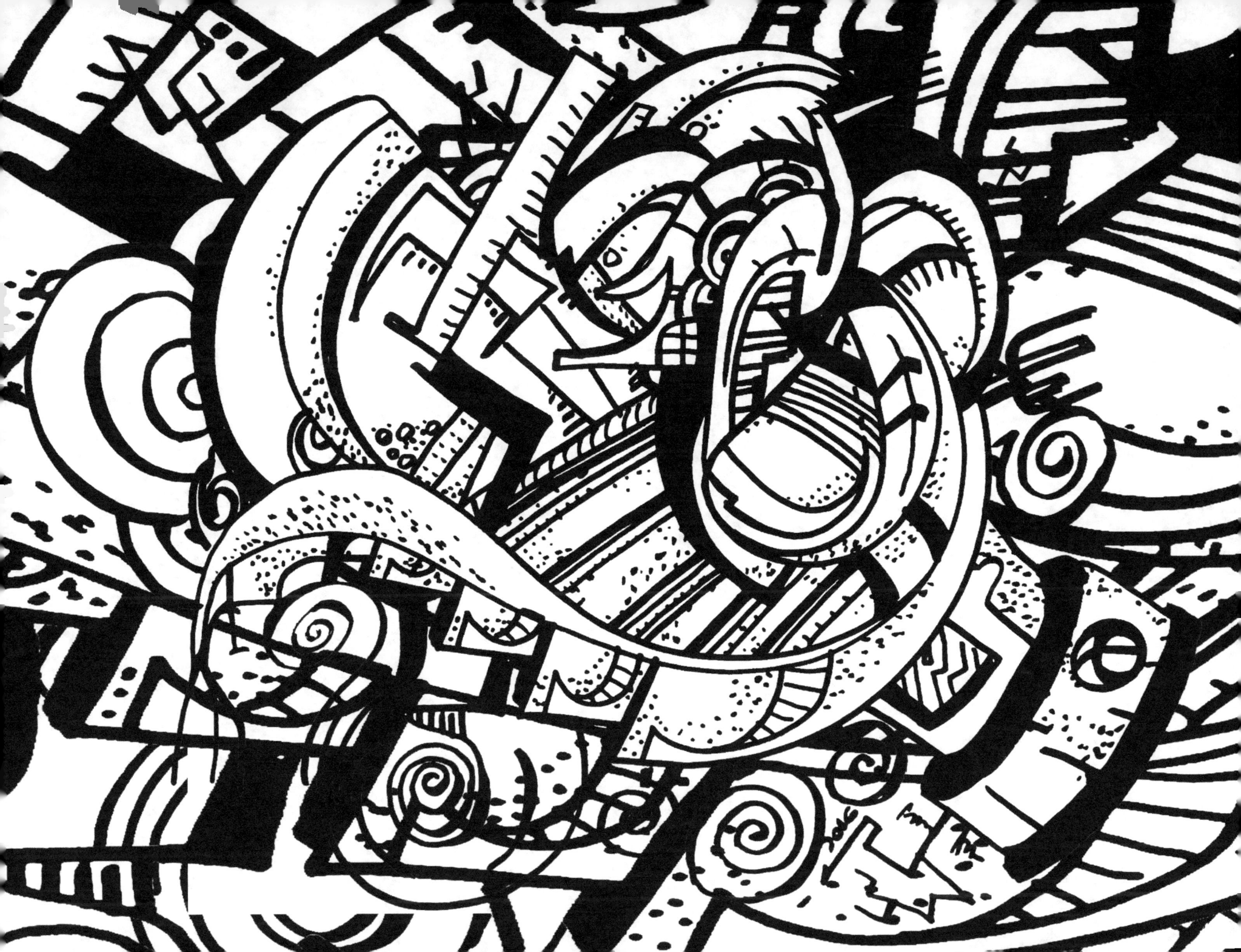

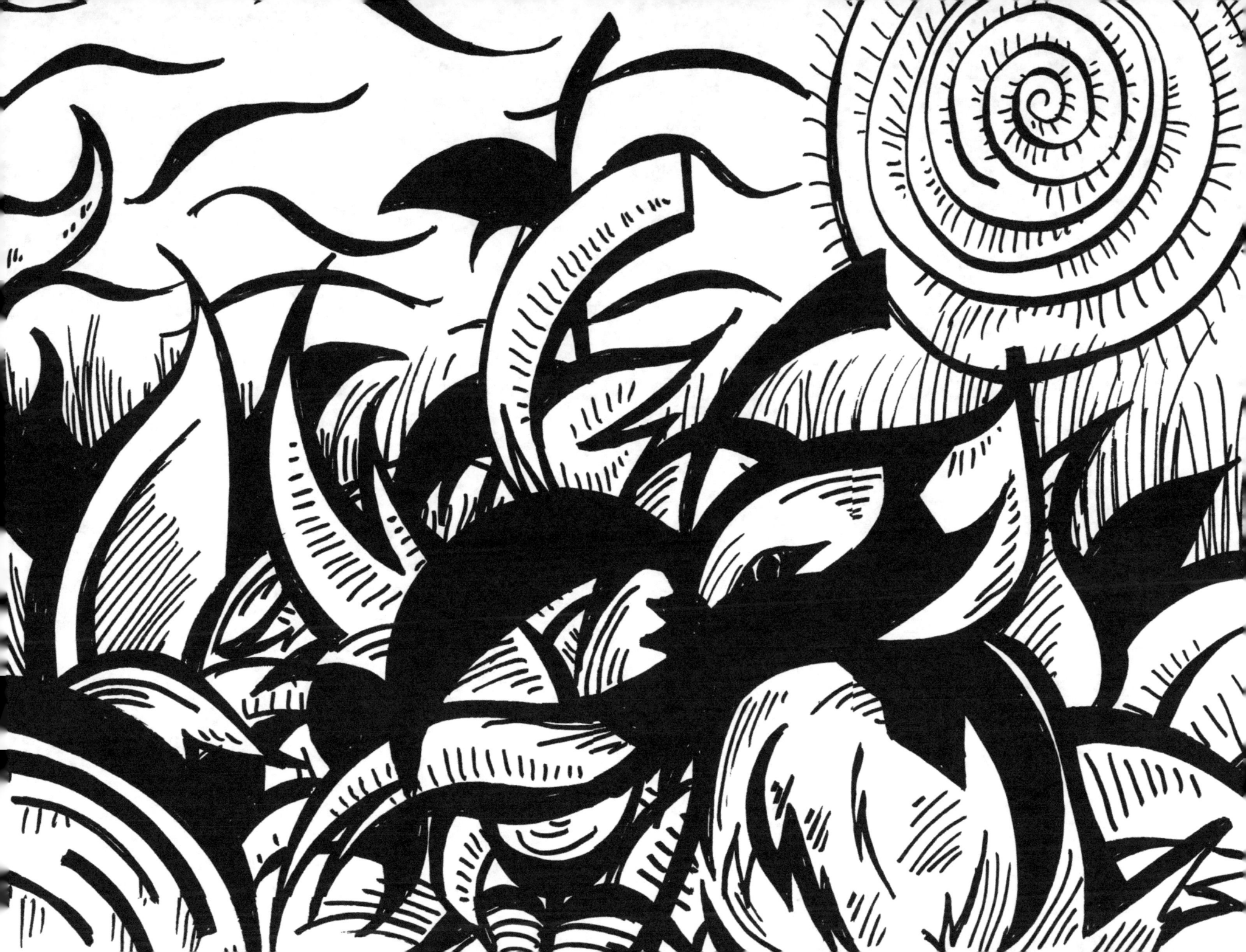

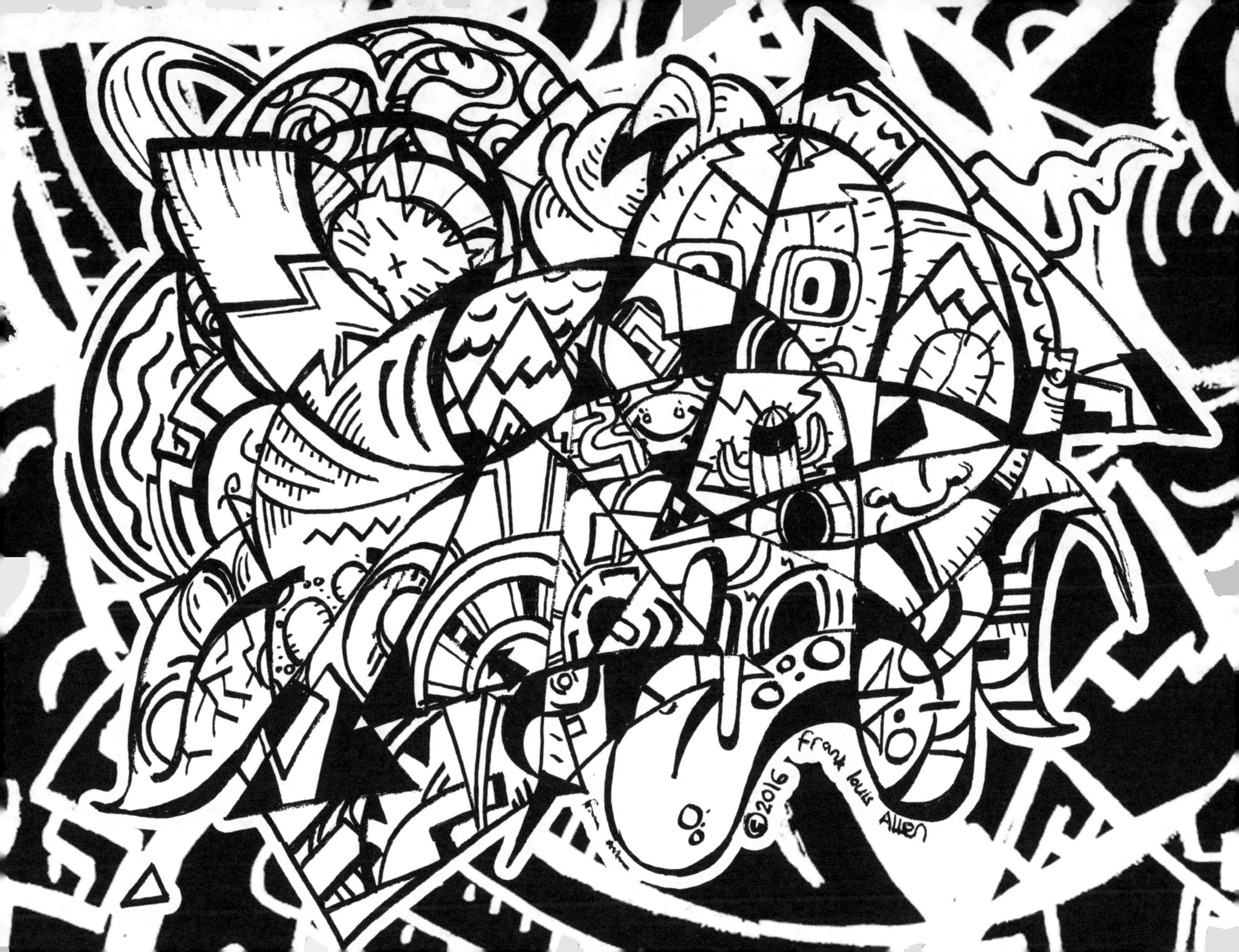

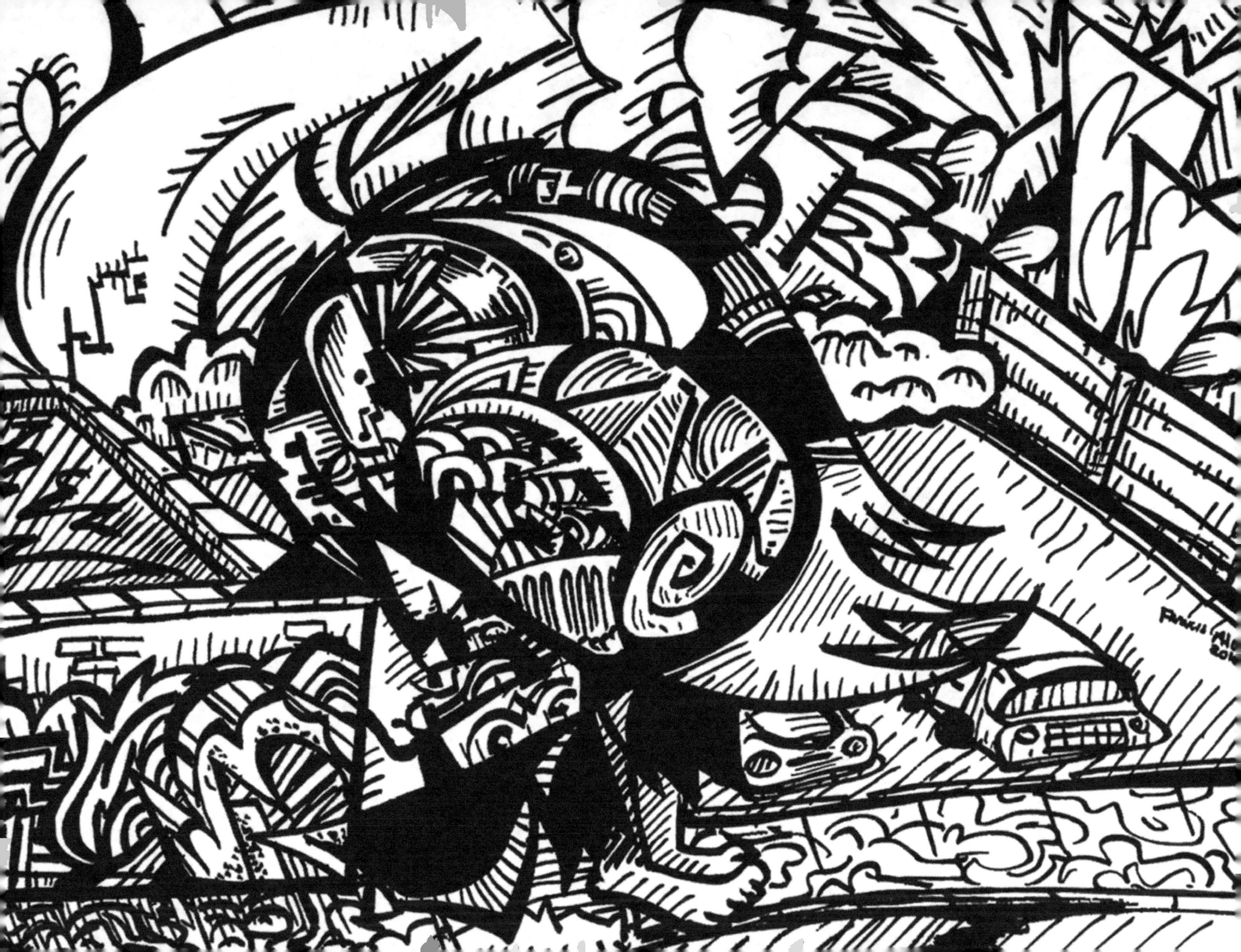

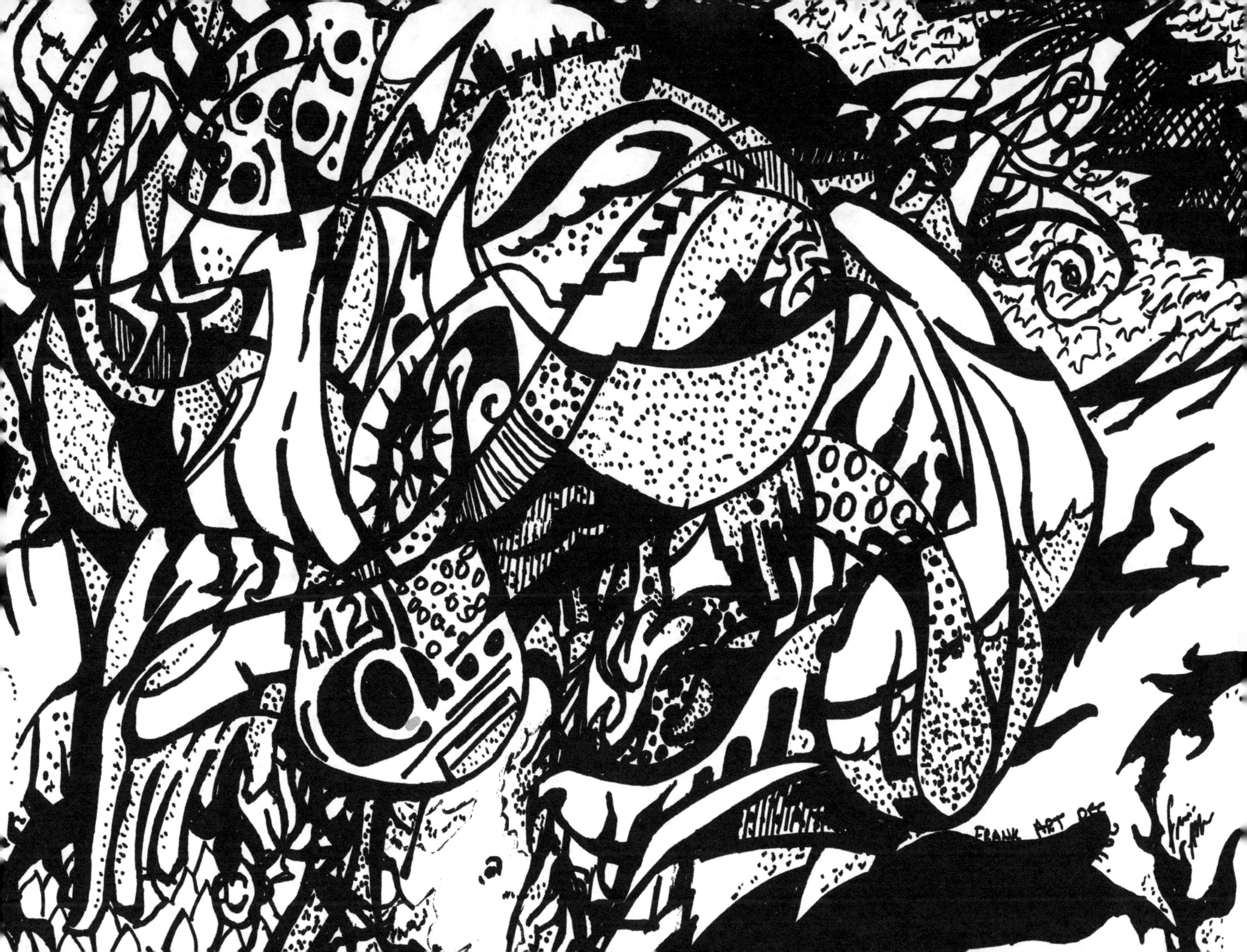

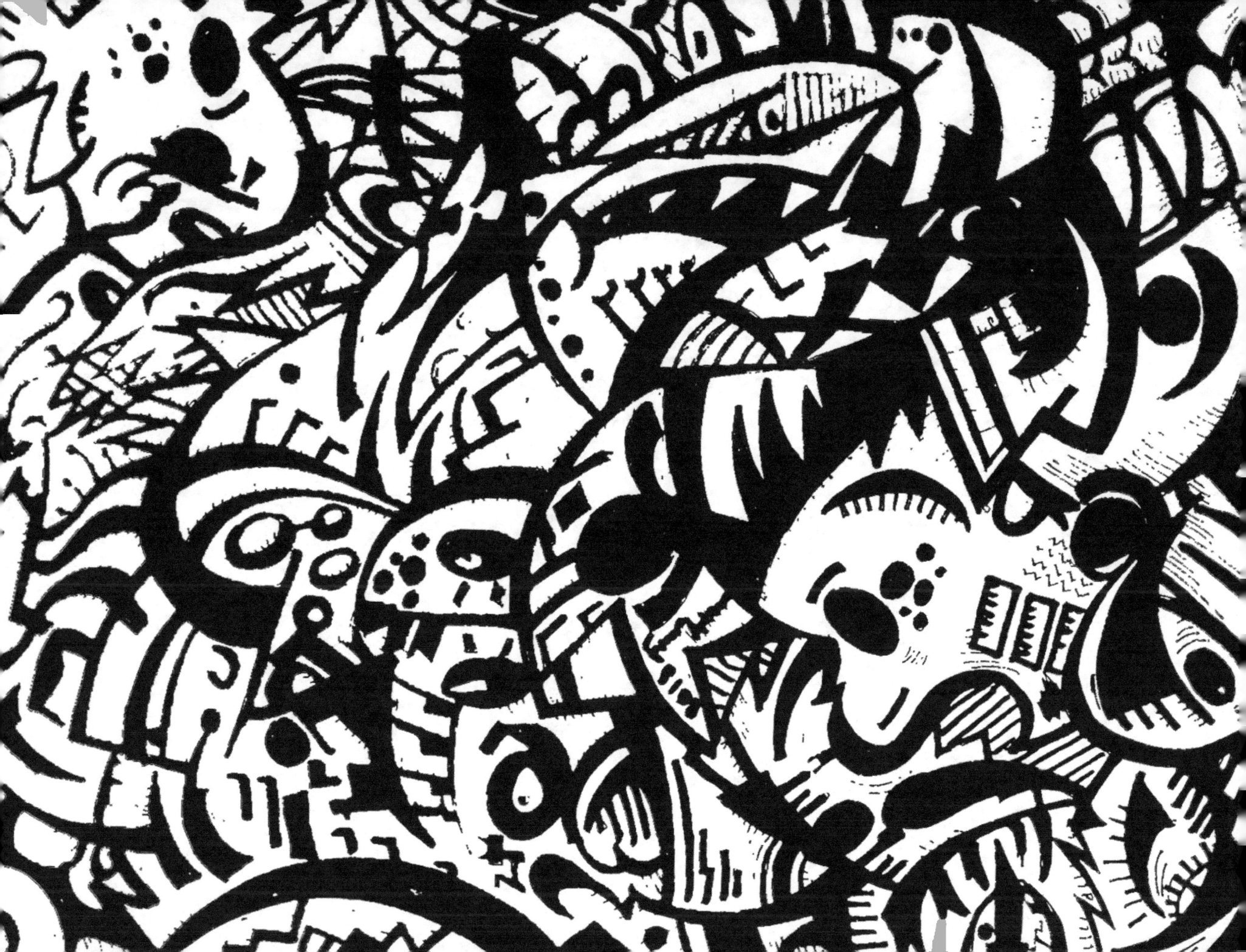

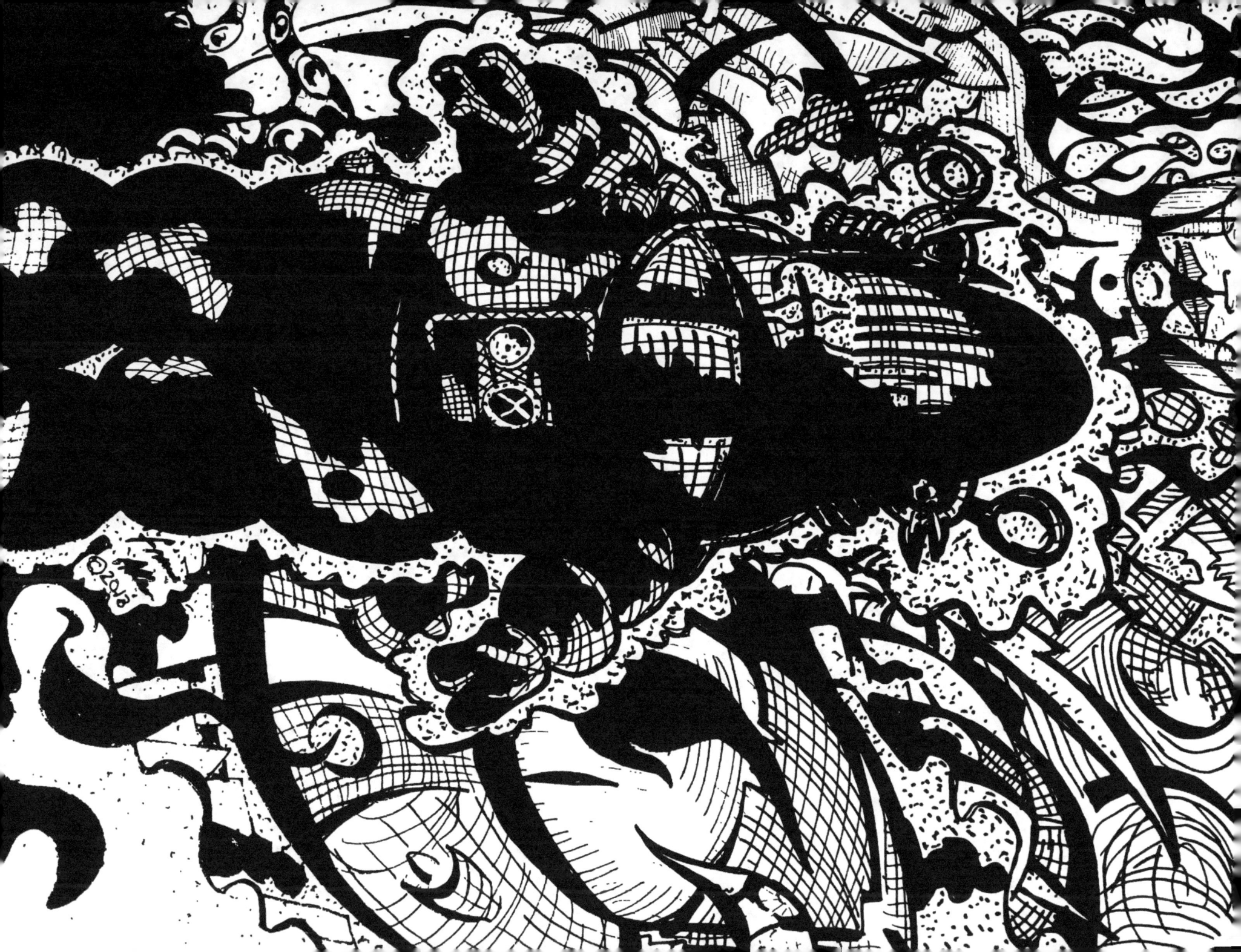

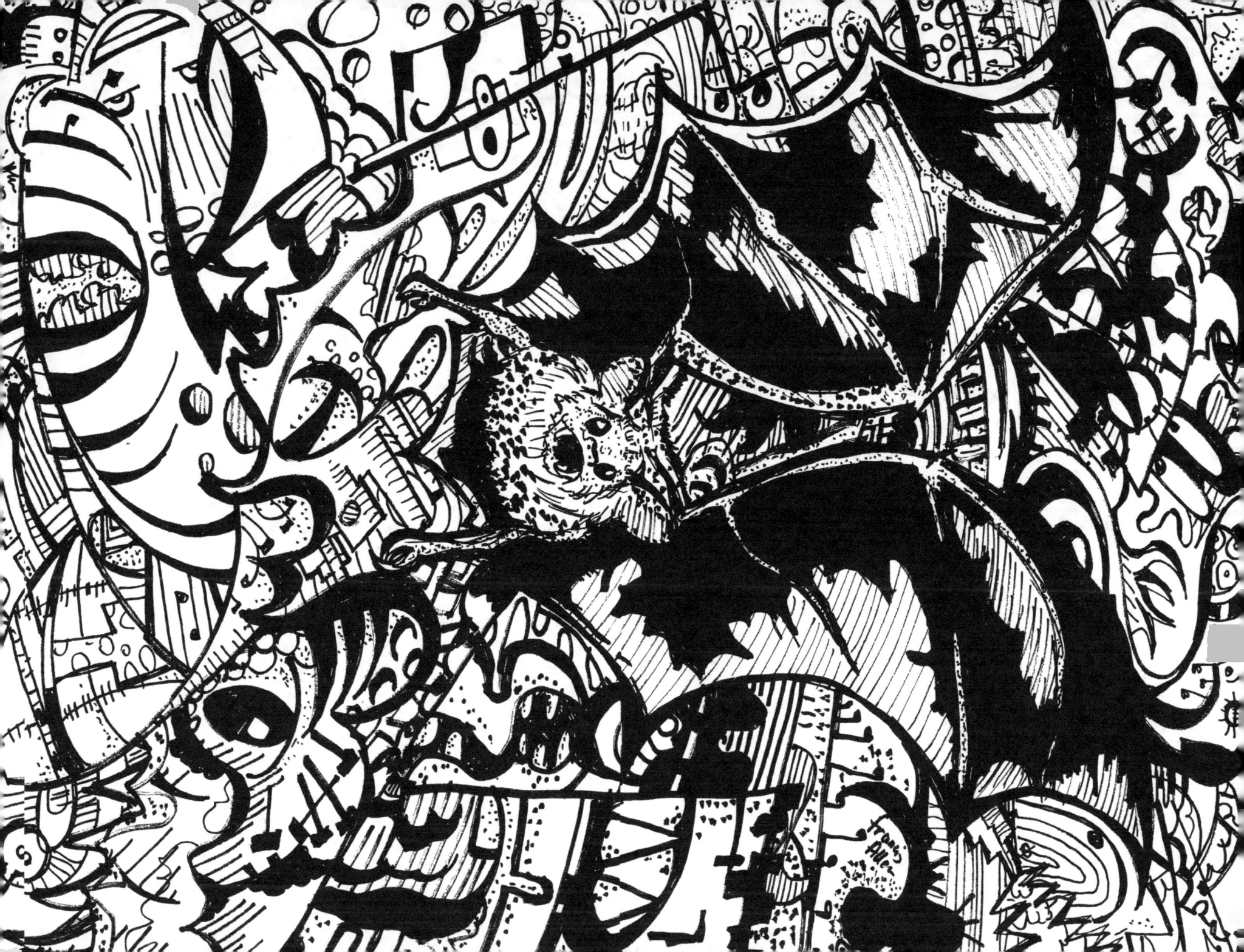

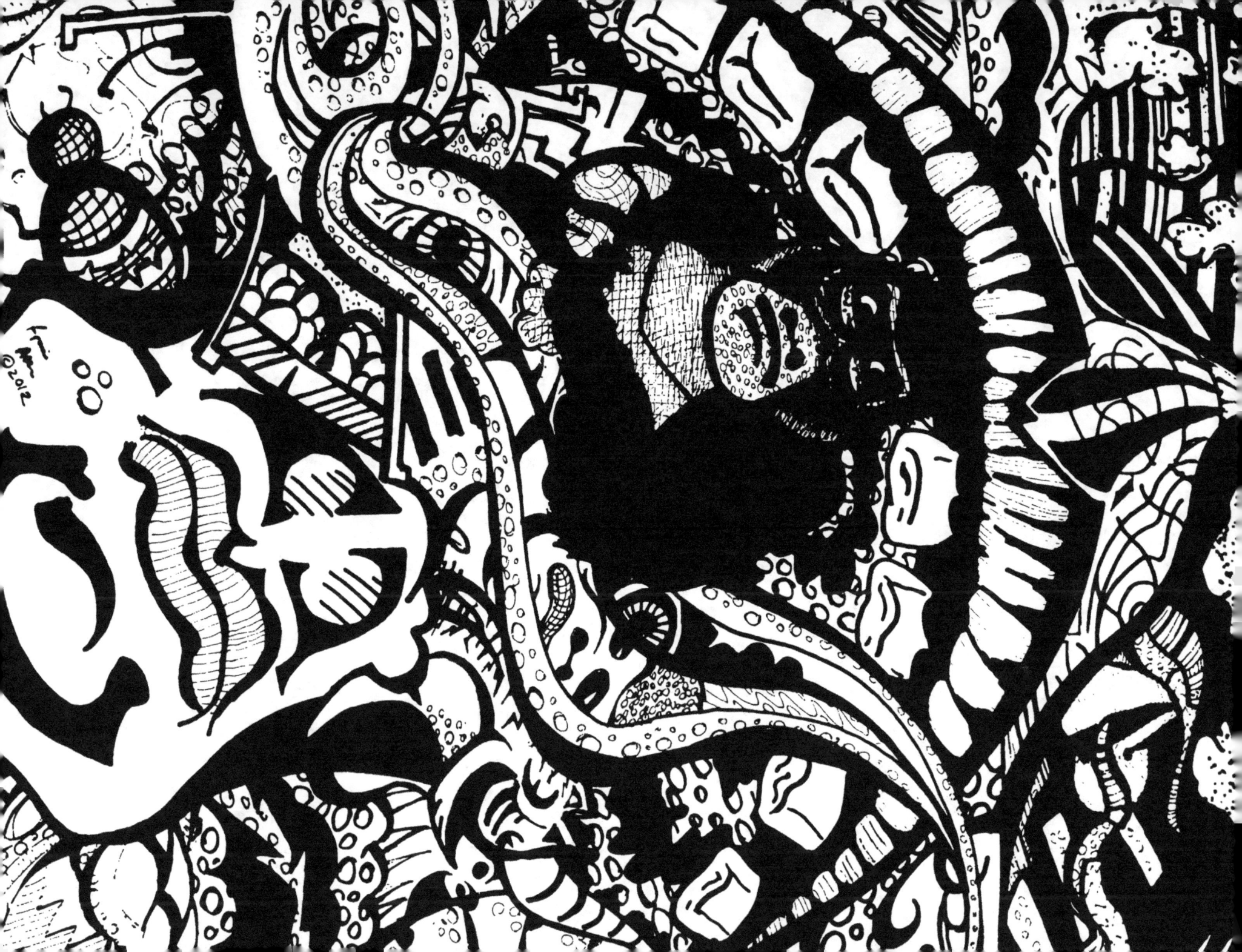

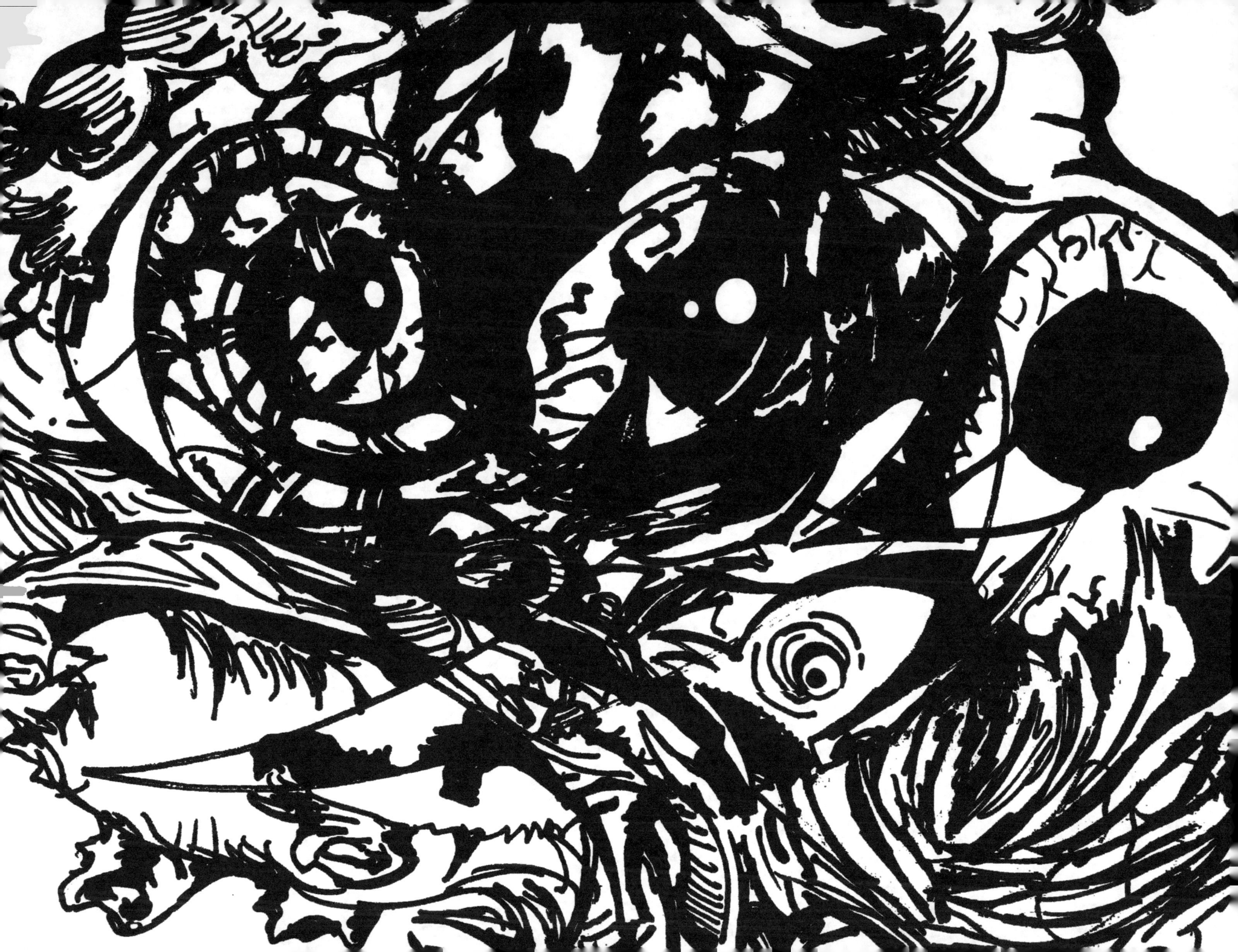

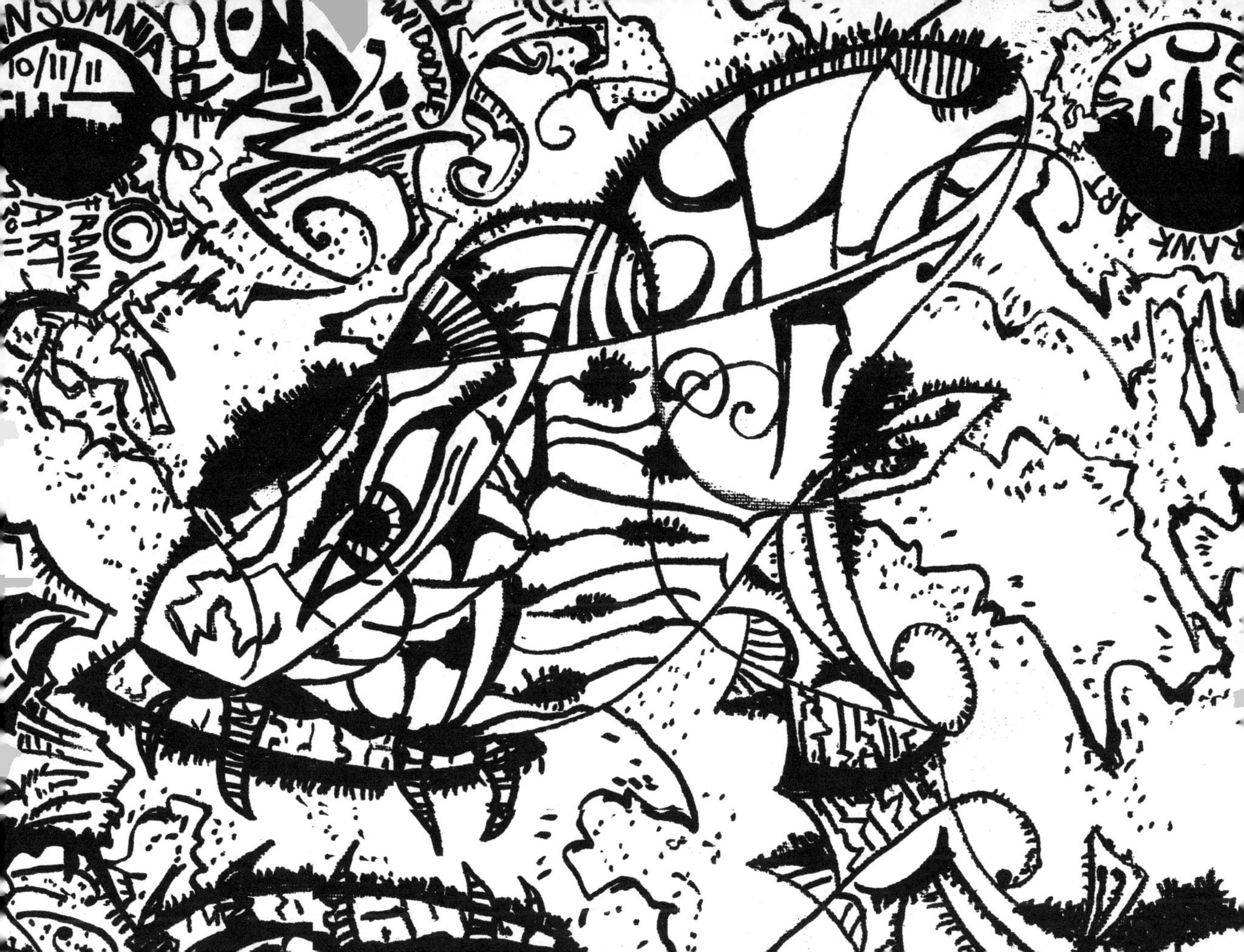

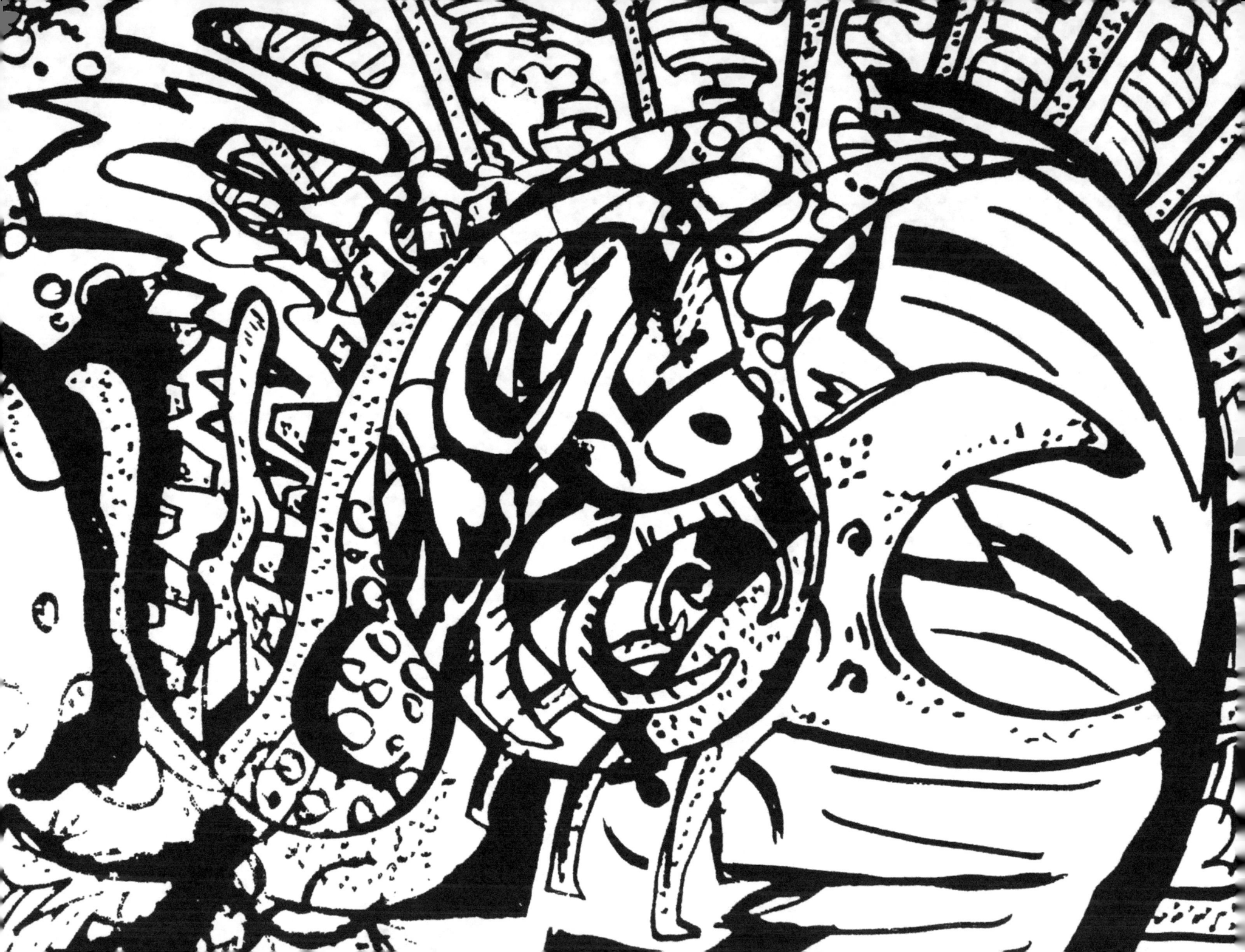

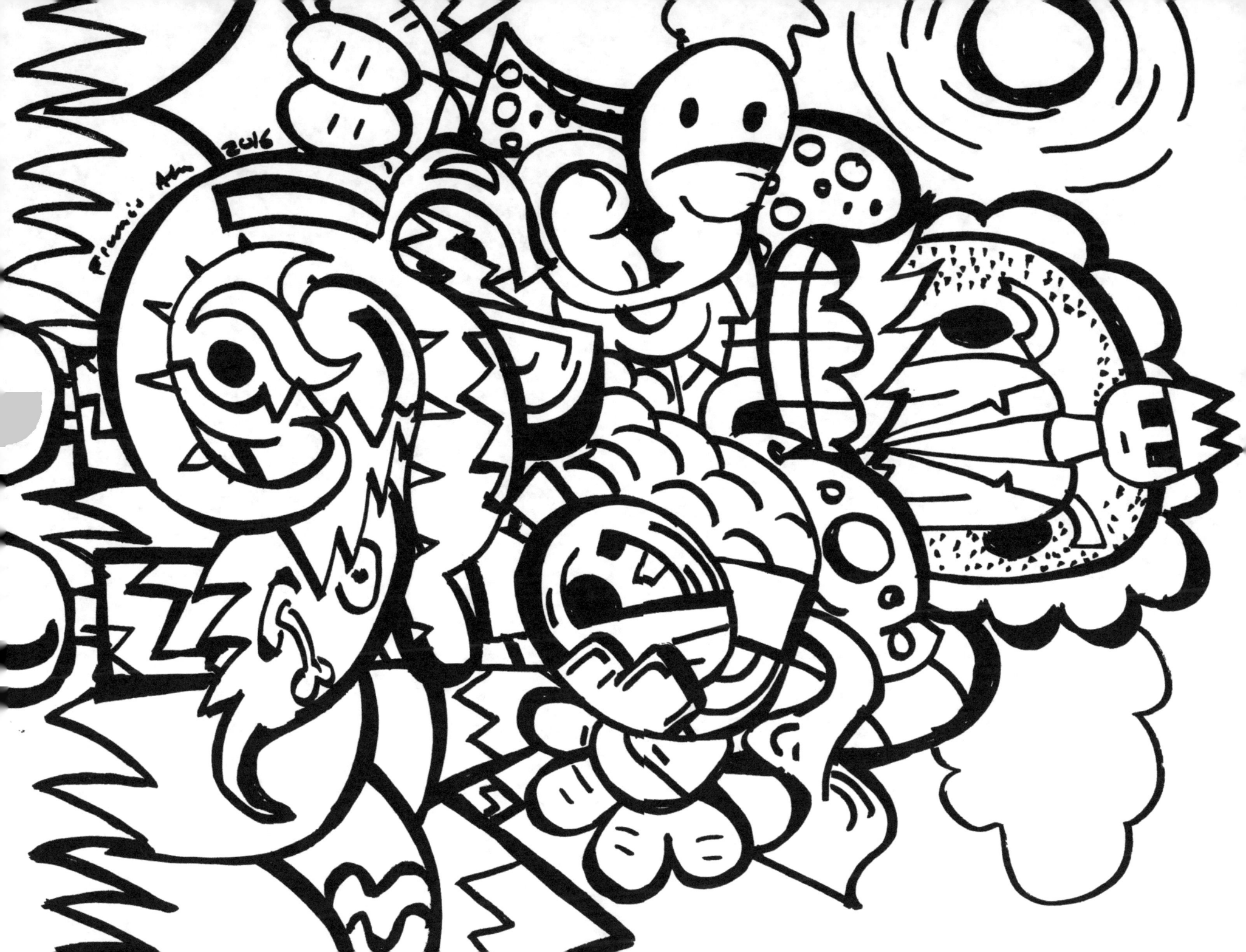

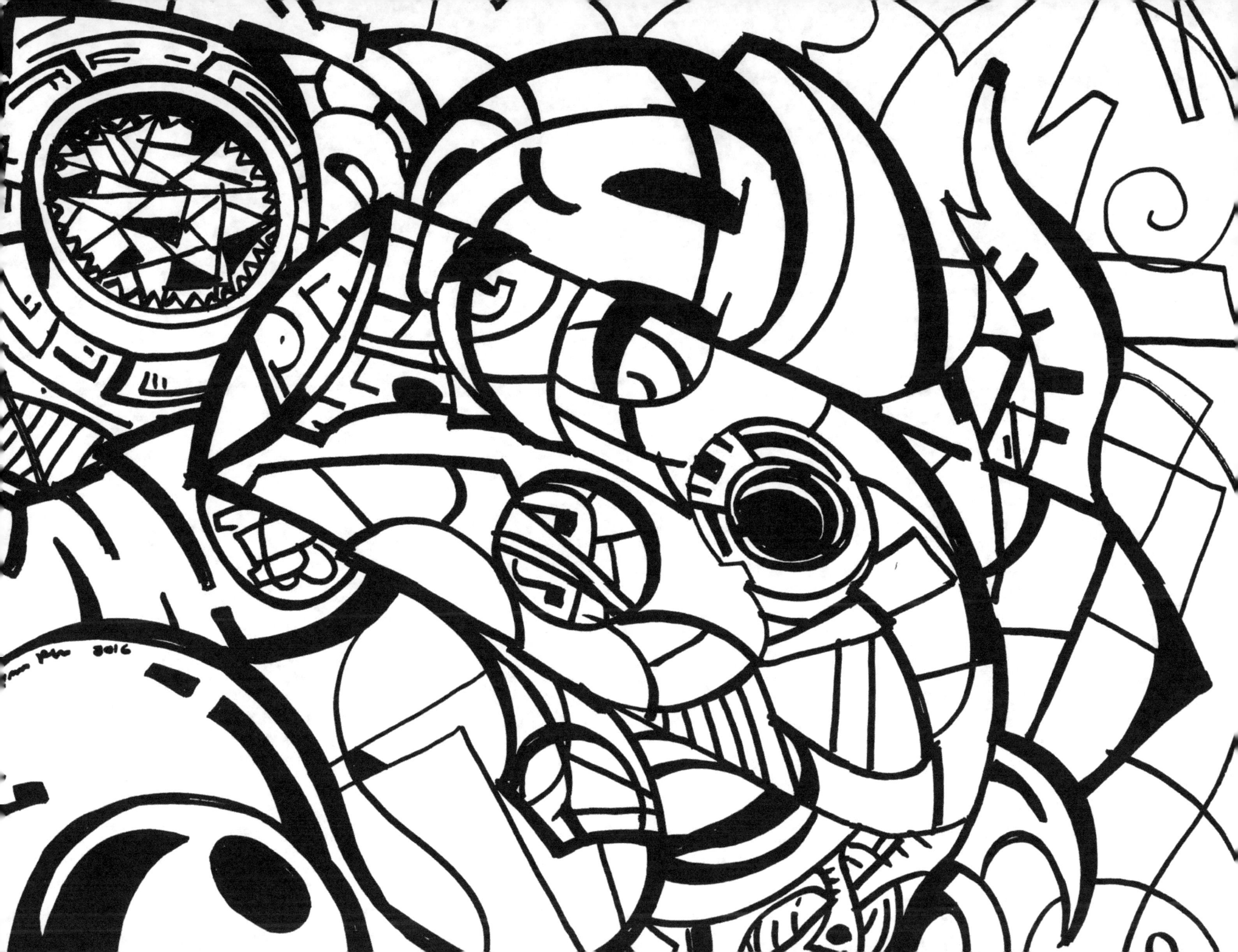